Dec "92"

Dear Shell,

my crazy, cooky,
weird, platform wearing
slick do - Best Friend
I thought these books
were just darling. Most
of these pictures are
of nature - which reminded
me of our friendship
natural. We-us-4-some
are all so close
as close as the poppies
at Argenteuil 1873 (pg 19.)
I love ya Darling
Love,
Wendy

Monet
Paintings

WINGS BOOKS
New York • Avenel, New Jersey

Introduction
Copyright © 1992 by Outlet Book Company, Inc.
All rights reserved.

This 1992 edition is published by Wings Books,
distributed by Outlet Book Company, Inc.,
a Random House Company,
40 Engelhard Avenue, Avenel, New Jersey, 07001.

Grateful acknowledgement is made to Superstock, Art Resource and The Granger
Collection for permission to use their transparencies of the artwork.

Printed and bound in Singapore

Library of Congress Cataloging-in-Publication Data

Monet, Claude, 1840–1926.
 Monet paintings.
 p. cm.
 ISBN 0-517-07761-2
 1. Monet, Claude, 1840–1926—Catalogs. 2. Miniature books—
Catalogs. I. Title.
ND553.M7A4 1992
759.4—dc20 92-2726
 CIP

8 7 6 5 4 3 2 1

The only virtue in me is my submission to instinct...Capturing the ephemeral changes of light and atmosphere...are the very essence of painting. Perhaps my originality boils down to being a hypersensitive receptor...

—CLAUDE MONET

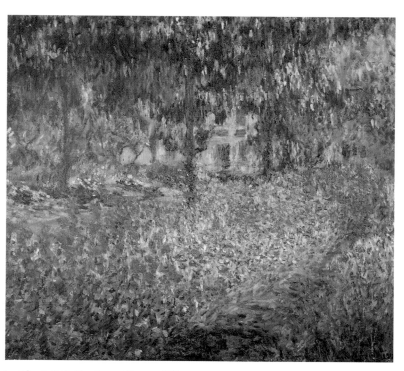

1. *The Artist's Garden at Giverny* 1900

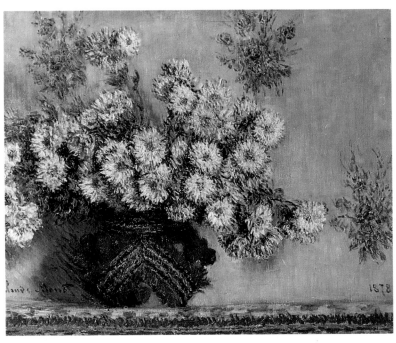

2. *Chrysanthemums* 1878

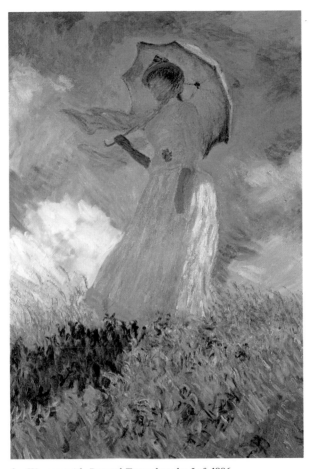

3. *Woman with Parasol Turned to the Left* 1886

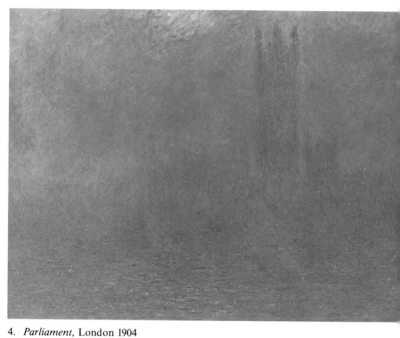

4. *Parliament*, London 1904

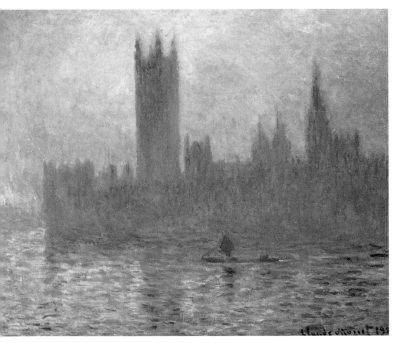

5. *The Houses of Parliament at Sunset* 1903

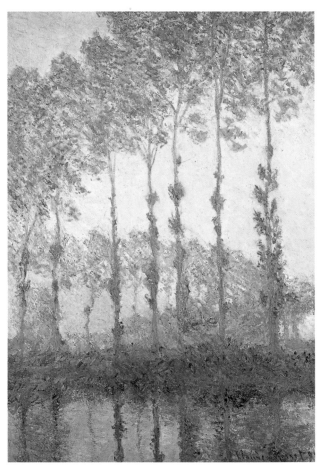

6. *Poplars on the Epte* 1891

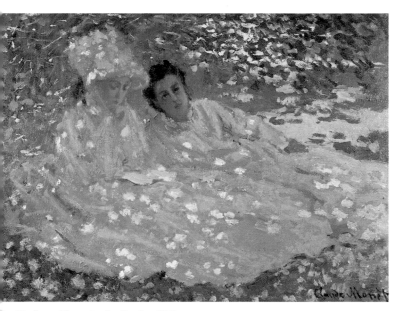

9. Madame Monet in the Garden 1872

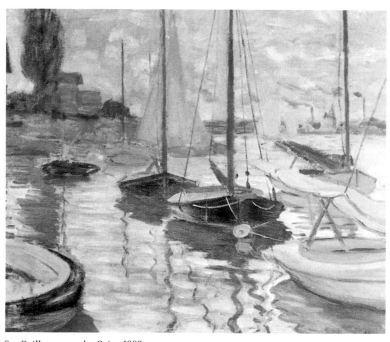

8. *Sailboats on the Seine* 1880

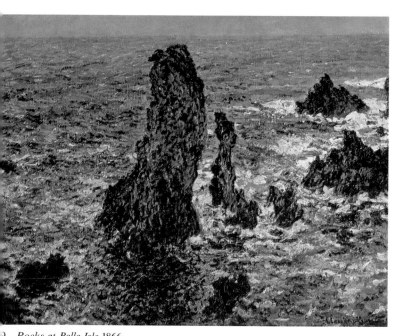

9. *Rocks at Belle Isle* 1866

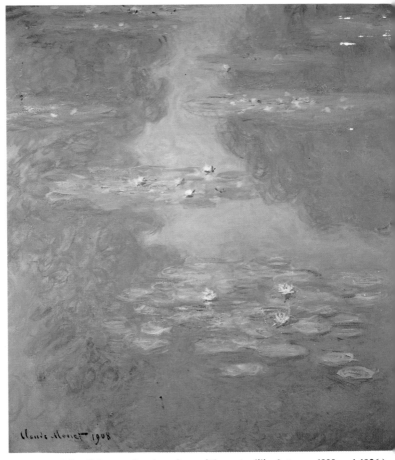

10. *Water Lilies* (Monet painted versions of the water lilies between 1900 and 1926.)

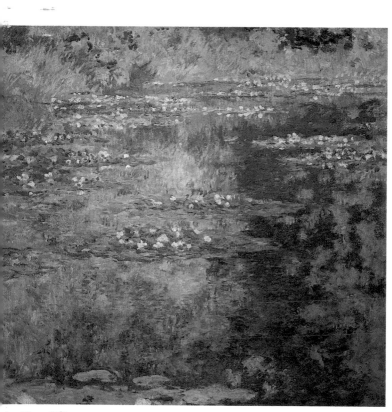

1. *Water Lilies*

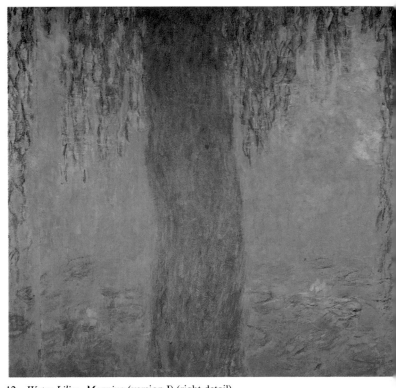

12. *Water Lilies, Morning* (version I) (right detail)

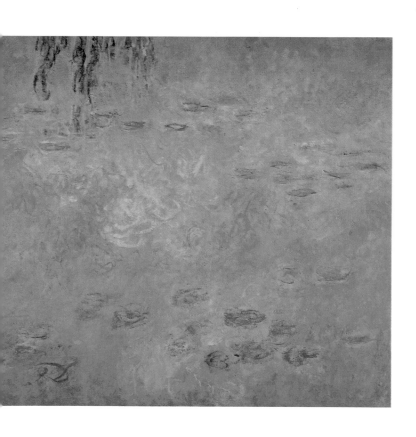

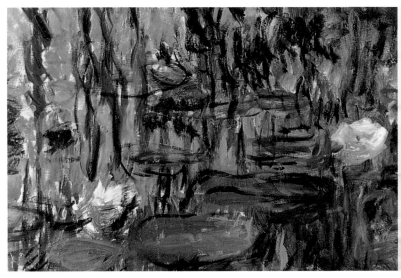

13. *Water Lilies* Detail

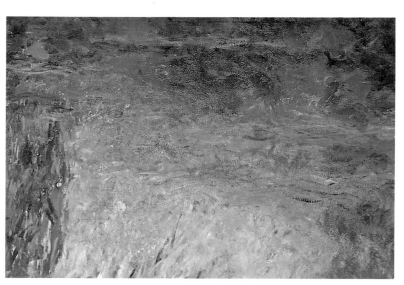

14. *Water Lilies, Sunset* Detail

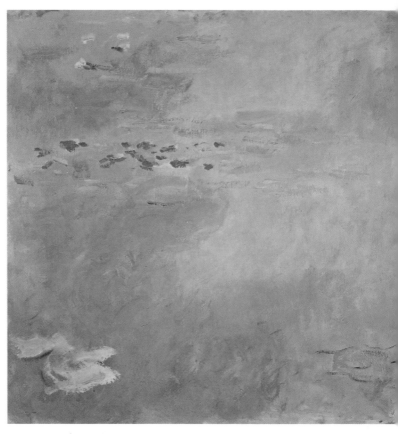

15. *Water Lilies at Giverny*

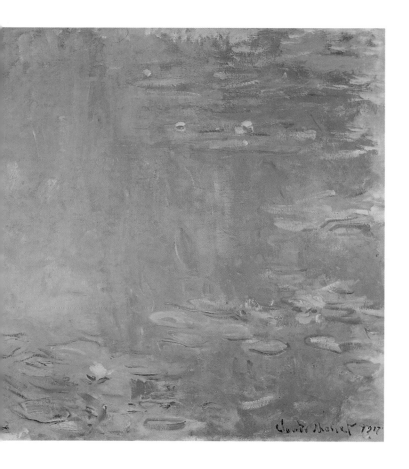

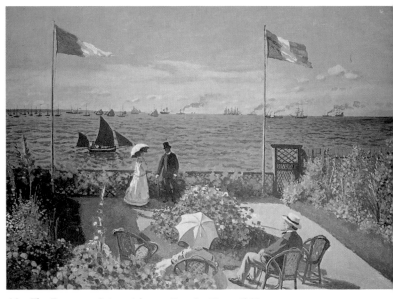

16. *The Terrace at Sainte Adresse, Near Le Havre* 1866

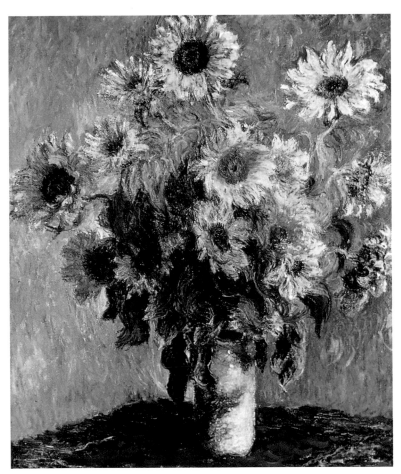

17. *Sunflowers* 1881

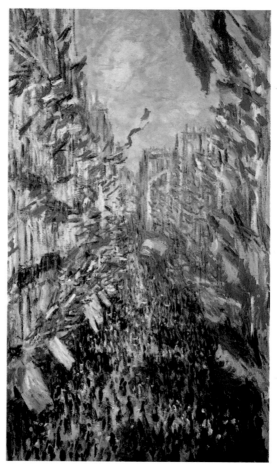

18. *La Rue Montorgueil, Festival of June 30.* 1878

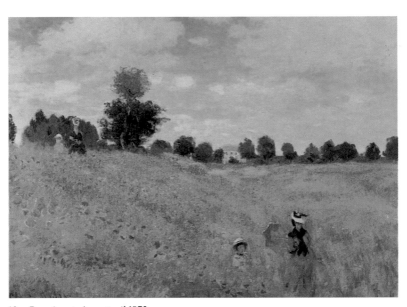

19. *Poppies at Argenteuil* 1873

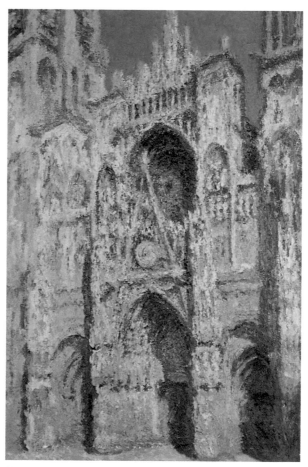

20. *Rouen Cathedral, Bright Sunlight* 1894

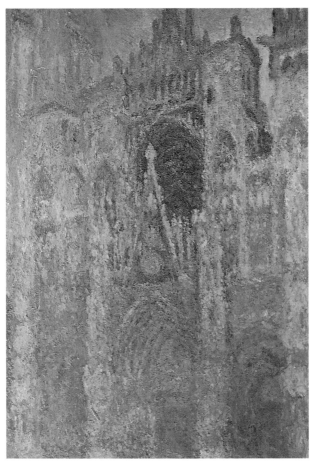

21. *Western Portal of Rouen Cathedral, Harmony in Blue* 1894

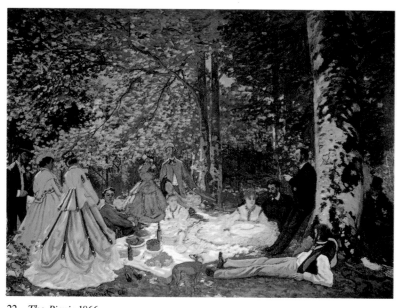

22. *The Picnic* 1866

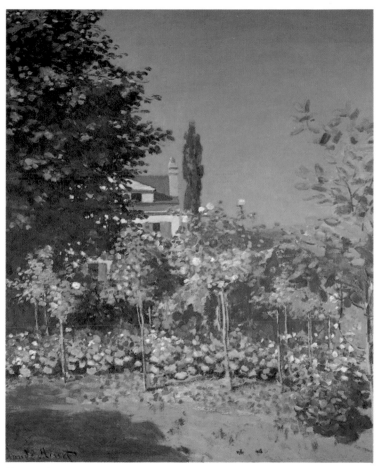

23. *Garden in Bloom at Sainte-Adresse* 1866

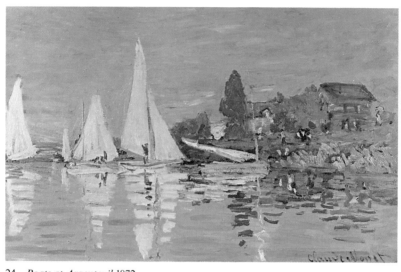

24. *Boats at Argenteuil* 1872

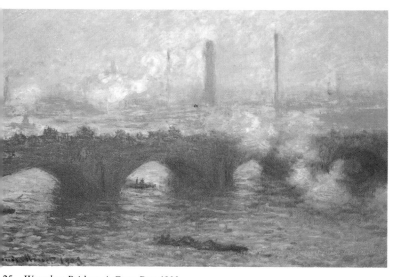

25. *Waterloo Bridge: A Grey Day* 1903

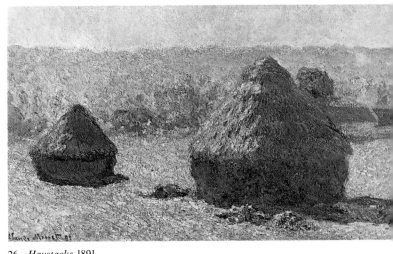

26. *Haystacks* 1891

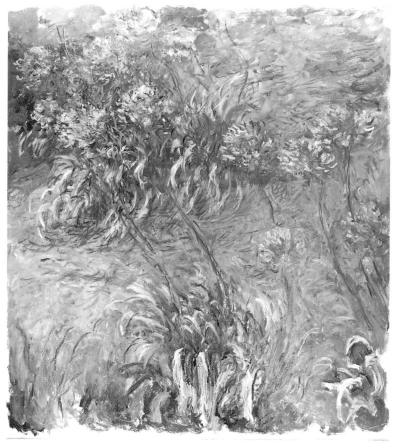

27. *Impression, Flowers* 1915

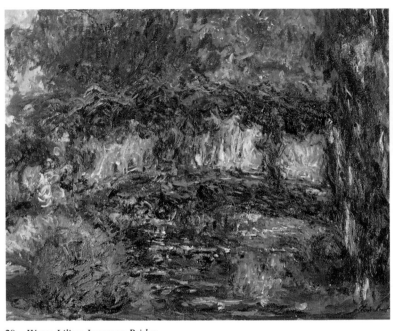

28. *Water Lilies: Japanese Bridge*

Afterword

By 1860 when Claude Monet moved to Paris from Le Havre, where he had spent his childhood, he was twenty years old and already an accomplished caricaturist. His work had attracted the attention of the painter Eugène Boudin, who, impressed by the young man's precise eye, encouraged him to paint landscapes directly from nature. Monet had to spend two years serving in the army in Algeria, but by 1863 he was back in Paris studying at the studio of Charles Gleyre and exploring new styles and motifs.

Paris in the middle of the last century was the center of artistic innovation. For the most part the artists were reacting against the rigid traditional taste displayed in the Paris Salon, the "official" French art. The exhibitions held in the Salon showed work chosen by the Salon jury and to be included meant professional prestige and often money for the artist. In 1866 the jury accepted Monet's "The Green Dress", a portrait of his wife Camille. It seemed an auspicious debut, and among the young artist's admirers was novelist Émile Zola who recognized in the work the birth of a new talent:

Here we have more than a realist, someone who knows how to interpret each detail with delicacy and power.... Notice the dress, how supple it is, how solid. It trails softly, it is alive, it declares loud and clear who this woman is.[1]

But as Monet continued to experiment, the Salon juries didn't seem to understand his more innovative works and after the one acceptance his paintings were rejected. Other artists who were also being rejected by the official judges included Claude Renoir, Edouard Manet, Camille Pissaro, Edgar Degas, Berthe Morisot and others who have since been recognized as masters. Finally, in 1874, this group joined together to form the Société Anonyme des Artistes Peintres, Sculpteurs, Graveurs, etc. and mounted an independent exhibition of their work.

That landmark show heralded a revolution in the art world. One of the paintings, Monet's "Impression: Sunrise," provided a convenient tag for critics, and the name Impressionists was born. But most traditional critics, who didn't understand the innovative techniques, were hostile and made fun of the work. Critic Louis Leroy was derisive about Monet's "Fishing Boats Leaving the Port":

> But these blotches were done the way they whitewash granite for a fountain: slip! slop! vlim! vlam! Any old how! It's unheard of, dreadful![2]

And two years later Albert Wolfe in *Le Figaro* reported that the public was equally scornful:

> Some people burst out laughing at the sight of these things, but they just leave me heartsick. These self-declared artists style themselves the intransigents, the impressionists; they take canvas, paint, and brushes, throw some color on at random, and sign the results.[3]

Despite this, the group continued to mount exhibitions until 1886, by which time the works of the Impressionists had been accorded more general acceptance. Monet's own fortunes had also changed

for the better in the 1880s. After years of poverty when he had been cut off by his disapproving bourgeois family and was dependent on his friends for financial support, Monet's paintings started to command high prices. During a stay in London in 1870 he had met the dealer Durand-Ruel, who became an important advocate—and seller—of the works of Monet and other Impressionists. In 1891, Monet was the first Impressionist to have a one-man show in New York; a second exhibit was held in Boston in 1892.

By 1890 his paintings were selling so well that he was able to purchase a house and property in Giverny which would be his home, and the inspiration for some of his best-known work, until he died in 1926.

> The only virtue in me is my submission to instinct.... Capturing the ephemeral changes of light and atmosphere... are the very essence of painting. The subject doesn't matter! One instant, one aspect of nature is all that is needed! Perhaps my originality boils down to being a hypersensitive receptor, and to the expediency of a shorthand by means of which I project on canvas, as if on a screen, impressions registered by my retina.[4]

Monet's modest description of his talent belies not only his dedication to his work but the verdict of history. When he escaped from the studio to paint *en plein air*, he set himself a task which he accomplished spectacularly: the perfect rendering on canvas of the interplay of reality and reflection and of the effects of light and atmosphere on the colors his eyes perceived.

Throughout his long life, from his painting "Rocks at Belle Isle" (plate 9) to "Boats at Argenteuil" (plate 24) to the Poplars series (plate 6) to the Water Lilies done in the last years of his life, water was a dominant motif in Monet's work. Not only was he fascinated by the

reflections and dance of the sun on the surface; the constantly changing movement of waves epitomized for Monet the fleeting nature of time. His trees and leaves, grasses, meadows, and liquid skies all shimmer with wavelike surfaces.

Another Impressionist, Berthe Morisot, once said of Monet's work, "Whenever I look at one of his paintings, I know instinctively which way to point my parasol."[5] Monet sought to go beyond light and shadow in his art, to capture the diffuse quality of light. Impatient with the inadequate results obtained by contrasting dark and light tints, the method used by most of his contemporaries, Monet created intensity by painting one pale tint against a second so that light seemed to reflect from one object to another. It is this technique that endows his paintings with a breathtaking luminosity. And his desire to depict the true nature of light would also lead to his series paintings. In an interview with François Thiebault-Sisson, Monet recalled:

> I told myself that it would be interesting to study the same motif at different times of day and to discover the effects of light that changed...from hour to hour....I began my series of *Haystacks* [plate 26]....The series of *Cathedrals* followed after a five or six year interval. It is thus that, without seeking to do so, one discovers newness.[6]

Monet's approach to painting demanded more than just a change of venue, it called upon new methods of applying paint to canvas. The painter who hopes to capture a fleeting moment, to render in paints nature as it is immediately perceived, has no time to mix colors; a passing cloud, a breath of wind will alter the landscape. Adapting the technique of Courbet, an artist he much admired, Monet painted with broad, quick brush strokes. Observing him at

Giverny, the painter and journalist Georges Jeanniot wrote:

> He paints with a full brush and uses four or five pure colors; he juxtaposes or superimposes the unmixed paints on the canvas. His landscape is swiftly set down and could, if necessary, be considered complete after only one session which lasts...as long as the effect he's seeking lasts.... He is always working on two or three canvases at once: he brings them all along and puts them on the easel as the light changes.[7]

Viewed close up Monet's paintings are patches of color, breaking apart the texture of matter; the patch of color became for Monet a primary reality. Like the artists of Japan and China, Monet saw the human figure as another element within the natural landscape, a sensation of color to be preserved as a pure immediate impression. In paintings such as "Madame Monet in the Garden" (plate 7), the boundaries between the human figure and the surroundings melt into one another; the crowds in "La Rue Montorgueil" (plate 18) become a stream of color. In his paintings of Rouen cathedral (plates 20 and 21) and "The Houses of Parliament at Sunset" (plate 5), the very stones dissolve into flowing, near-transparent surfaces of color. As the critic Arsene Alexandre wrote:

> Here is an artist who, in our own time, has multiplied the harmonies of color, has gone as far as one person can into the subtlety, opulence, and resonance of color. He has dared to create effects so true-to-life as to appear unreal, but which charm us irresistibly, as does all truth revealed.[8]

For sixty years, Monet, who lived until 1926 and continued to work even as an old man, explored and redefined the nature of painting. Because he outlived most of his contemporaries, he alone

among the Impressionists was able to witness the evolution of the movement from a subject for scorn to its vindication within the art world. His own works reflect a continuum that stretches from the realistic paintings of the Barbizon school to the birth of modern abstraction, hinted at in the fusion of water, light, and sky in the *Water Lilies* series. Spanning nearly three decades, Monet's work continually evolved despite his failing eyesight and increased frailty.

And his work continues to enthrall viewers. In 1891, the novelist and art critic Octave Mirbeau captured the essence of Monet's appeal:

> This extraordinary poet of tender light and veiled shapes...this man whose paintings breathe are intoxicated, scented; this man who has touched the intangible, expressed the inexpressible, and whose spell over our dreams is the dream that nature so mysteriously enfolds....[9]

More than thirty years later, on the occasion of the installation of the Water Lilies murals in the museum of the Orangerie after Monet's death in 1926, his old friend, journalist and politician Georges Clemenceau, wrote:

> And thus does art bring to life, before our dry eyes, the happy trembling of the liquid sward, of the blue sky, of the cloud, of the flower, and all have something to tell us that they could not tell us were it not for Monet.[10]

NOTES

1. Charles F. Stuckley, editor, *Monet: A Retrospective* (New York: Park Lane), 34
2. Ibid, 57
3. Ibid, 60
4. Ibid, 266-7
5. Yvon Taillandier, *Monet* (New York, Crown Publishers, Inc.), 68
6. Stuckley, 346-347
7. *Monet's Years at Giverny* (New York: The Metropolitan Museum of Art), 21
8. Stuckley, 223
9. Ibid, 159
10. Ibid, 356

List of Plates

The photographs in this book were supplied by: